Artists in Times of War

Artists in Times of War

∾

HOWARD ZINN

An Open Media Book

SEVEN STORIES PRESS
New York

Open Media series editor, Greg Ruggiero.

In Canada: Hushion House, 36 Northline Road, Toronto, Ontario M4B 3E2

In the U.K.: Turnaround Publisher Services Ltd., Unit 3, Olympia Trading Estate, Coburg Road, Wood Green, London N22 6TZ

In Australia: Palgrave Macmillan, 627 Chapel Street, South Yarra, VIC 3141

Cover photo and design: Greg Ruggiero
Photo taken September 14, 2001, Union Square, New York City

LIBRARY OF CONGRESS CATALOGING-IN-PUBLICATION DATA

Zinn, Howard, 1922-
Artists in times of war / Howard Zinn.
 p. cm.
Includes bibliographical references (p.).
ISBN 1-58322-602-8 (pbk : alk. paper)
1. Peace movements—United States—History. 2. Government, Resistance to—United States—History. 3. Art and society—United States. 4. Artists—United States—Political activity—History. 5. War on Terrorism, 2001– 6. Goldman, Emma, 1869-1940. 7. Anarchists—United States—Biography. 8. Motion pictures—Political aspects—United States. 9. Pamphleteers—United States—History. 10. Protest movements—United States—History. I. Title.
JZ5584.U6 Z56 2003
303.6'6--dc22 2003020849

Printed in Canada.

9 8 7 6 5 4 3 2 1

Contents

≈

Artists in Times of War

~

An edited version of a talk given at Massachusetts College of Art, Boston, Mass., October 10, 2001.

When I think of the relationship between artists and society—and for me the question is always what it could be, rather than what it is—I think of the word *transcendent*. It is a word I never use in public, but it's the only word I can come up with to describe what I think about the role of artists. By transcendent, I mean that the artist transcends the immediate. Transcends the here and now. Transcends the madness of the world. Transcends terrorism and war.

The artist thinks, acts, performs music, and writes outside the framework that society has created. The artist may do no more than give us

7

beauty, laughter, passion, surprise, and drama. I don't mean to minimize these activities by saying the artist can do no more than this. The artist needn't apologize, because by doing this, the artist is telling us what the world should be like, even if it isn't that way now. The artist is taking us away from the moments of horror that we experience everyday—some days more than others—by showing us what is possible.

But the artist can and should do more. In addition to creating works of art, the artist is also a citizen and a human being. The way that society tends to classify us scares me. I am a historian. I don't want to be just a historian, but society puts us into a discipline. Yes, *disciplines* us: you're a historian, you're a businessman, you're an engineer. You're this or you're that. The first thing someone asks you at a party is, "What do you do?" That means, "How are you categorized?"

The problem is that people begin to think that's all they are. They're professionals in something. You hear the word *professionalism* being used

often. People say, "You have to be professional." Whenever I hear the word, I get a little scared, because that limits human beings to working within the confines set by their profession.

I face this as a historian. During the Vietnam War, there were meetings of historians. While the war was raging in Southeast Asia, the question was, "Should historians take a stand on the war?" There was a big debate about this. Some of us introduced a resolution saying that "We historians think the United States should get out of Vietnam." Other historians objected. They said, "It's not that we don't think the United States should get out, but we are just historians. It's not our business."

But whose business is it? The historian says, "It's not my business." The lawyer says, "It's not my business." The businessman says, "It's not my business." And the artist says, "It's not my business." Then whose business is it? Does that mean you are going to leave the business of the most important issues in the world to the people who run the country? How stupid can we be?

9

Haven't we had enough experience historically with leaving the important decisions to the people in the White House, Congress, the Supreme Court, and those who dominate the economy?

There are certain historical moments when learning is more compressed and intense than others. Since September 11, 2001, we have been in such a moment.

One of the things we learned about during the Vietnam War was experts. When the war started, people would ask, "Why are we there?" These experts would come on television and tell us why. The British actor Peter Ustinov spoke out against the war in Vietnam. Then somebody said, "Ustinov? He's an actor. He's not an expert." Ustinov made an important point. He said that there are experts in little things but there are no experts in big things. There are experts in this fact and that fact but there are no moral experts. It's important to remember that. All of us, no matter what we do, have the right to make moral decisions about the world. We must be undeterred by the cries

of people who say, "You don't know. You're not an expert. These people up there, they know." It takes only a bit of knowledge of history to realize how dangerous it is to think that the people who run the country know what they are doing. Jean-Jacques Rousseau said, "I see all sorts of people doing this and that but where are the citizens among us?" Everyone must be involved. There are no experts.

So the word *transcendent* comes to mind when I think of the role of the artist in dealing with the issues of the day. I use that word to suggest that the role of the artist is to transcend conventional wisdom, to transcend the word of the establishment, to transcend the orthodoxy, to go beyond and escape what is handed down by the government or what is said in the media. Some people in the arts and in other professions think, "Yes, let's get involved. Let's get involved in the way we are told to." You see them getting into line in the way they are expected to when the president asks them to do so. And that is echoed by everyone else in politics.

How many times have I read in the press since September 11 that "We must be united"? What do they mean by that? I would like us to be united. But united around what? When people say we must be united, they state explicitly or implicitly that we must be united around whatever the president tells us to do.

CBS news anchor Dan Rather is an anchor of the establishment. He has gone on TV and said, "Bush is my president. When he says get into line, I get into line." After I heard Rather's comments, I thought, here is an important and influential journalist who's forgotten the first rule of journalism: Think for yourself. He's forgotten what I.F. Stone, one of the greatest journalists of the twentieth century, once said. Stone used to write for major newspapers until he realized he wasn't allowed to say certain things. So he left the mainstream media and set up his own newsletter, *I.F. Stone's Weekly*. It became famous for providing information that you couldn't get anywhere else. He was invited to speak to journalism classes. He told the students, "I am going

to tell you a number of things, but if you really want to be a good journalist you only have to remember two words: *governments lie*. Not just the U.S. government, but, in general, all governments lie." That may sound like an anarchist statement, but the anarchists have something there. They are right to be skeptical and suspicious of those who hold official power, because the tendency of those who hold that power is to lie in order to maintain it.

When Dan Rather made his statement, he violated the Hippocratic oath of journalists, which implies that you must think for yourself. Rather's comment is the kind you would expect from a journalist in a totalitarian state, but not from someone in a democracy.

Then you have Al Gore, who accepted his defeat so graciously that he became humble. Overwhelmingly humble. So much so that when September 11 happened, Gore announced, "Bush is my commander in chief." I thought, I don't think he's read the Constitution. The Constitution says the president is the commander in chief of the

13

armed forces only. He's not the commander in chief of the entire country. Gore's behavior is another example of people rushing to get into line, to get inside the perimeter of power.

It is the job of the artist to transcend that—to think outside the boundaries of permissible thought and dare to say things that no one else will say. Fortunately, throughout history we have had artists who dared to do this. I think of Mark Twain, the great novelist who wrote stories that everyone loved. When the United States went to war against Spain in 1898, Twain spoke out. Spain was quickly defeated in what was called "a splendid little war." But when the United States went after the Philippines, that wasn't a splendid little war. It was long and ugly. The Filipinos wanted to rule themselves.

Twain was one of the voices speaking out against this war, which in many ways foreshadowed the Vietnam War. By 1906, the war had been going on for five years and several hundred thousand Filipinos were dead. You won't find much in your history books about that. The U.S.

Army committed a massacre. You might call it an act of terrorism in the sense that innocent people were mowed down. Six hundred men, women, and children were murdered. President Theodore Roosevelt sent a message to General Leonard Wood, who carried out this operation against virtually unarmed Muslims in the southern Philippines: "I congratulate you and the officers and men of your command upon the brilliant feat of arms wherein you and they so well upheld the honor of the American flag." Twain denounced Roosevelt. He became one of the leading protesters against the war in the Philippines. He stepped out of his role as just a storyteller and jumped into the fray.[1]

Twain dared to say things that so many in the country were not saying. Of course, right away, his patriotism was questioned. As soon as you speak outside the boundaries, as soon as you say things that are different from what the establishment, the media, and leading intellectuals are telling you to say, the question of your patriotism arises.

Twain wrote something very interesting

about loyalty in his novel *A Connecticut Yankee in King Arthur's Court*:

> You see my kind of loyalty was loyalty to one's country, not to its institutions or its officeholders. The country is the real thing, the substantial thing, the eternal thing; it is the thing to watch over, and care for, and be loyal to; institutions are extraneous, they are its mere clothing, and clothing can wear out, become ragged, cease to be comfortable, cease to protect the body from winter, disease, and death. To be loyal to rags, to shout for rags, to worship rags, to die for rags—that is a loyalty of unreason, it is pure animal; it belongs to monarchy, was invented by monarchy; let monarchy keep it. I was from Connecticut, whose Constitution declares "that all political power is inherent in the people, and all free governments are founded on their authority and instituted for their benefit; and that they have at all times an undeniable and indefeasible right to alter their form of government in such a manner as they may think expedient."[2]

Mark Twain's idea of loyalty is important because, in the present discussion, boundaries have been set and lines have been drawn. Those who go outside those boundaries and criticize official policy are called unpatriotic and disloyal. When people make such accusations against dissenters, they have forgotten the meaning of loyalty and patriotism. Patriotism does not mean support for your government. It means, as Mark Twain said, support for your country. The feminist anarchist Emma Goldman said, at roughly the same time as Twain, that she loved the country but not the government.[3]

To criticize the government is the highest act of patriotism. If someone accuses you of not being patriotic, you ought to remind him or her of the Declaration of Independence. Of course, everyone praises the Declaration when it is hung up on a classroom wall, but not when people read it and understand it. During the Vietnam War, a soldier was disciplined for putting it up on his barracks wall. The Declaration of Independence says that governments are artificial creations.

They are set up by the people of the country to achieve certain objectives, the equality of all people and the right to "Life, Liberty and the pursuit of Happiness." And "whenever any Form of Government becomes destructive of these ends," the Declaration says, "it is the Right of the People to alter or to abolish it, and to institute [a] new Government." That's democratic doctrine. That's the idea of democracy. Therefore, there are times when it becomes absolutely patriotic to point a finger at the government to say that it is not doing what it should be doing to safeguard the right of citizens to life, liberty, and the pursuit of happiness.

Today everybody is talking about the fact that we live in one world; because of globalization, we are all part of the same planet. They talk that way, but do they mean it? We should test their claims. We should remind them that the words of the Declaration apply not only to people in this country, but also to people all over the world. People everywhere have the same right to life, liberty, and the pursuit of happiness. When

the government becomes destructive of that, then it is patriotic to dissent and to criticize—to do what we always praise and call heroic when we look upon the dissenters and critics in totalitarian countries who dare to speak out.

I want to point to some other artists who spoke out against war. The poet E. E. Cummings wrote "I sing of Olaf glad and big":

> i sing of Olaf glad and big
> whose warmest heart recoiled at war:
> a conscientious object-or
>
>
> but—though all kinds of officers
> (a yearning nation's blueeyed pride)
> their passive prey did kick and curse
> until for wear their clarion
> voices and boots were much the worse,
> and egged the firstclassprivates on
> his rectum wickedly to tease
> by means of skilfully applied
> bayonets roasted hot with heat—
> Olaf(upon what were once knees)
> does almost ceaselessly repeat
> "there is some shit I will not eat"[4]

E. E. Cummings and other writers were reacting to World War I, to that great martial spirit that was summoned up in 1917 to get the United States into the war. People were being herded into line, and the flag was being waved. When the war ended, people looked at the 10 million dead in Europe and asked, "What was this all about?" After the initial period of flag waving and bugle blowing, people began to think again— and to look at the terrible things they did. In war, terrible things are done on one side and terrible things are done on the other side. Then, after a while, the second thoughts come: What have we done? What have we accomplished? That's what happened after World War I.

That experience of World War I led to the writings of John Dos Passos, Ford Madox Ford, Ernest Hemingway, and to that great antiwar novel *Johnny Got His Gun*, by Dalton Trumbo.[5] I recommend that book to everyone. You can read it in one evening. You won't forget it.

It is important to remember that wars look good to many people in the beginning because

something terrible has been done, and people feel that something must be done in retaliation. Only later does the thinking and questioning begin.

Remember that World War II was the "good war." It wasn't until I was in a war that I realized that there are no such things as good wars and bad wars. I had a student who once wrote in her paper, "Wars are like wines. There are good years and bad years. But war is not like wine. War is like cyanide. One drop and you're dead."

Eugene O'Neill, the great playwright, wrote this to his son six months after Pearl Harbor, when the whole country was being mobilized for war:

> It is like acid always burning in my brain that the stupid butchering of the last war taught men nothing at all, that they sank back listlessly on the warm manure pile of the dead and went to sleep, indifferently bestowing custody of their future, their fate, into the hands of State departments, whose members are trained to be conspirators, card sharps, double-crossers and secret betrayers of their own people; into the hands of greedy capitalist ruling classes so

> stupid they could not even see when their
> own greed began devouring itself; into the
> hands of that most debased type of pimp,
> the politician, and that most craven of all
> lice and job-worshippers, the bureaucrats.[6]

Well, I would never use such strong language
myself, but I am willing to quote it when some-
body else says it.

When I talk about acting outside the bound-
aries that are set for us, I am thinking of the idea
of our national power and our national good-
ness—the idea that we are the superpower in the
world, and we deserve to be because we are the
best, and we have the most democracy and free-
dom. It's not only kind of arrogant to think that
terrible things are done to us because we are the
best—it is also a sign of a loss of history. We need
to bring ourselves down a peg, to the level of
other nations in the world. We need to able to
come down to earth and to recognize that the
United States has behaved in the world the way
other imperialist nations have. It's not surprising.

We have to be honest about our country. If we

are going to be anything, if there is anything an artist should be—if there is anything a citizen should be—it's honest. We must be able to look at ourselves, to look at our country honestly and clearly. And just as we can examine the awful things that people do elsewhere, we have to be willing to examine the awful things that are done here by our government.

Langston Hughes, the great African American poet, wrote a poem called "Columbia." For him, "Columbia" meant the United States:

> Columbia,
> My dear girl,
> You really haven't been a virgin for so long
> It's ludicrous to keep up the pretext.
> You're terribly involved in world assignations
> And everybody knows it.
> You've slept with all the big powers
> In military uniforms,
> And you've taken the sweet life
> Of all the little brown fellows
> In loin cloths and cotton trousers.
> When they've resisted,
> You've yelled, "Rape,"

. . . .

Being one of the world's big vampires,
Why don't you come on out and say so
Like Japan, and England, and France,
And all the other nymphomaniacs of power
Who've long since dropped their
Smoke-screens of innocence
To sit frankly on a bed of bombs?[7]

We live in a rich and powerful country and, yes, a country with great traditions like the Declaration of Independence and the Bill of Rights. But our greatest traditions and proudest experiences have come not from government but from what the people of the United States have done when they have banded together to fight against injustices like slavery. They have come from what working people have done to change the conditions of their own lives because the government would do nothing. Well, the government would do something. It would send the troops and the National Guard and the police out to club and shoot workers.

We have to think about what kind of country

we want to be in the world and whether it is important for us to be a superpower. What should we take pride in? That we are the strongest? That we are the richest? That we have the most nuclear weapons? That we have the most TVs and cars? Are those the things we want to be most proud of? Is that really strength, or is it something else?

One of the artists whose work I think of as transcendent is Joseph Heller, the author of *Catch-22*.[8] If, right after World War II, someone had written a nonfiction book on the ambiguities of war and the atrocities committed by the supposed good guys—if someone had written suggesting that "the greatest generation," as Tom Brokaw calls it,[9] was not necessarily the greatest; that the conflict was much more complicated, because war corrupts everyone who engages in it, and soon the good guys would begin to look like the bad guys—such a book would have been difficult to publish. There was such a glow surrounding that war. But Heller could write a novel like *Catch-22*. Artists can be sly. They can point

to things that take you outside traditional thinking because you can get away with it in fiction. People say, "Oh, well it's fiction." But remember what Pablo Picasso said: "Art is a lie that makes us realize truth."[10] Art moves away from reality and invents something that may be ultimately more accurate about the world than what a photograph can depict.

Joseph Heller was one of these writers who could use fiction to say things that could not easily be said in nonfiction. Yossarian is Heller's crazy bombardier protagonist. He's crazy because he doesn't want to fly any more missions. He's had enough of war. If he wanted to bomb, he'd be sane.

At one point in the novel, another character in the book, Nately, is in a brothel in Italy talking to an old Italian. He's puzzled because the man says that America will lose because it's so strong and Italy will survive because it's so weak.[11] The old man wasn't talking about losing or winning the war. He was talking about the long run of history. It makes you think again about what we define as strength and what we define as weak-

ness. The strong, by extending their strength to every corner of the world, become more and more vulnerable—and, as a result, ultimately weaker. The old man and Nately have another interesting exchange about nationalism:

"There is nothing so absurd about risking your life for your country!" [Nately] declared.

"Isn't there?" asked the old man. "What is a country? A country is a piece of land surrounded on all sides by boundaries, usually unnatural. Englishmen are dying for England, Americans are dying for America, Germans are dying for Germany, Russians are dying for Russia. There are now fifty or sixty countries fighting in this war. Surely so many countries can't all be worth dying for."[12]

Heller also has a powerful passage in *Catch-22* about the impact of the war on civilians. When a number of his troops are about to go out on a bombing run, General Peckem explains, "They'll be bombing a tiny undefended village,

reducing the whole community to rubble."[13] Heller had been a bombardier in the air force. He understood the nature of bombing and how you often pretend to be bombing military targets so you will believe it. But it is the nature of bombing that you never bomb only military targets.

Kurt Vonnegut also wrote a novel set during World War II, *Slaughterhouse-Five*.[14] He wrote about the British and American bombing of Dresden, in which perhaps 100,000 civilians died. To write about this and denounce it in nonfiction would have been difficult, but Vonnegut was able to reveal the horror of Dresden in a novel.

During the Vietnam War, artists spoke out in different ways against the war. The poet Robert Lowell was invited to the White House and he refused. Arthur Miller also refused an invitation. The singer Eartha Kitt was invited to the White House for a social event in January 1968. Here was a singer who was not supposed to be paying any attention to the war, but at the event she

spoke out against it. She told Lady Bird Johnson, "You send the best of this country off to be shot and maimed."[15] It was shocking. An artist was not supposed to do such things.

But artists were doing all sorts of things during that period to show that they were citizens and that they were thinking outside the boundaries. They showed that they were transcending the given wisdom. An artist named Seymour Chwast did a poster that was reproduced everywhere. It was a very simple poster. It just said, "War is Good for Business—Invest Your Son."

Great music was being written and performed during that era by musicians who insisted on being considered not just as musicians but as people who were so moved by what was going on that they had to say something. Bob Dylan wrote his song, "Masters of War":

> Come you masters of war
> You that build all the guns
> You that build the death planes
> You that build the big bombs
> You that hide behind walls

Howard Zinn

You that hide behind desks
I just want you to know
I can see through your masks

You that never done nothin'
But build to destroy
You play with my world
Like it's your little toy
You put a gun in my hand
And you hide from my eyes
And you turn and run farther
When the fast bullets fly

Like Judas of old
You lie and deceive
A world war can be won
You want me to believe
But I see through your eyes
And I see through your brain
Like I see through the water
That runs down my drain

You fasten the triggers
For the others to fire
Then you set back and watch
When the death count gets higher
You hide in your mansion
As young people's blood

Flows out of their bodies
And is buried in the mud

You've thrown the worst fear
That can ever be hurled
Fear to bring children
Into the world
For threatening my baby
Unborn and unnamed
You ain't worth the blood
That runs in your veins

. . . .

Let me ask you one question
Is your money that good
Will it buy you forgiveness
Do you think that it could
I think you will find
When your death takes its toll
All the money you made
Will never buy back your soul.[16]

The trick in acting transcendentally is to think,
What questions are the voices of authority not
asking?

I am saying all this at a time when it is unpop-
ular to speak against the bombing of Afghanistan

or Iraq. The undeniable truth is that some fanatical group killed 3,000 people in New York City and Washington. The government has leapt from that to "Therefore, we must bomb."

We've always met violence with violence. But if you knew some history when this happened, you would ask, "What was the result?"

It would help to redefine the word "terrorism." What happened on September 11 was an act of terrorism. But to isolate it from the history of terrorism will dangerously mislead you. This act of terrorism exploded in our faces because it was right next door. But acts of terrorism have been going on throughout the world for a long time. I bring that up not to minimize or diminish the terror of what happened in New York and Washington but to enlarge our compassion beyond that. Otherwise, we will never understand what happened and what we must do about it.

When we enlarge the question and define terrorism as the killing of innocent people for some presumed political purpose, then you

find that all sorts of nations, as well as individuals and groups, have engaged in terrorism. Along with individual and group terrorism, there is state terrorism. When states commit terrorism, they have far greater means at their disposal for killing people than individuals or organizations.

The United States has been responsible for acts of terrorism. When I say that, people might say, "You are trying to minimize what was done." No, I'm not trying to do that at all. I'm trying to enlarge our understanding. The United States and Britain have been responsible for the deaths of large numbers of innocent people in the world. It doesn't take too much knowledge of history to see that. Think of Vietnam, Laos, and Cambodia. Millions died because the United States was interested in "the rubber, tin and other commodities" of the region.[17] Think of Central America. Think of the 200,000 dead in Guatemala as a result of a government that the United States armed and supported.

I know all this is unsettling. We don't want to

hear criticism of the U.S. government when we have been the victims of a terrorist act. But we have to think carefully about what we have to do to end terrorism. We have to think about whether bombing and occupying Afghanistan or Iraq is going to stop terrorism. Is further terrorism going to stop it? Because war is terrorism. War in our time inevitably involves the killing of innocent people.

So far, the United States has killed as many or more people in Afghanistan as lost their lives on September 11.[18] There are perhaps hundreds of thousands of Iraqis who have died in Iraq as a result of the current and previous Gulf Wars and the sanctions we have imposed and enforced. It is not a matter of measuring—they killed more than us or we killed more than them. We have to see all these things as atrocities and figure out what to do about it. You can't respond to one terrorist act with war, because then you are engaging in the same kind of actions that terrorists engage in. That thinking goes like this: "Yes, innocent people died, too

bad. It was done for an important purpose. It was 'collateral damage.' You must accept 'collateral damage' when you are doing something important." That's how terrorists justify what they do. And that's how nations justify what they do.

I am asking all of us to think carefully and clearly. For if we are all being herded into actions that will make the world even more dangerous than it is now, we will later regret that we went along silently and did not raise our voices as citizens to ask, "How can we get at the roots of this problem? Is it right to meet violence with violence?" All of us can do something, can ask questions, can speak up.

I want to end by quoting a poem by the peace activist Daniel Berrigan. He has long struggled against war and militarism. He wrote this poem in the memory of his friend Mitch Snyder, who had worked for many years for the homeless in Washington, D.C. Snyder became disconsolate that the government was building jet planes, bombers, nuclear submarines, and missiles, but

it didn't have enough money to take care of the homeless. Snyder became so depressed by this situation that he killed himself. Berrigan wrote this poem:

In Loving Memory—Mitchell Snyder

Some stood up once and sat down,
Some walked a mile and walked away.
Some stood up twice then sat down,
I've had it, they said.

Some walked two miles, then walked away,
It's too much, they cried.
Some stood and stood and stood.
they were taken for fools
they were taken for being taken in.

Some walked and walked and walked.
They walked the earth
they walked the waters
they walked the air.

Why do you stand?
they were asked, and
why do you walk?

Artists in Times of War

Because of the children, they said, and
because of the heart, and
because of the bread.

Because
the cause
is the heart's beat
and the children born
and the risen bread.[19]

Emma Goldman, Anarchism, and War Resistance

∽

Edited version of a speech given at Radcliffe College, Cambridge, Mass., January 29, 2002.

I can never stay with history; I can never just stay with the past. I became a historian, and went into the past, for the purpose of trying to understand and do something about what is going on in the present. I never wanted to be the kind of historian who goes into the archives and you never hear from him again.

My work on Emma Goldman has always been connected to the things in the world with which I am active and involved. But I had only been vaguely been aware of her before the 1960s. It was interesting—there I was, a Ph.D. in history,

and what could be higher than that? Who could be better informed than a Ph.D. in history? So there I was with a doctorate from Columbia University—and Emma Goldman had never been mentioned in any of my classes, none of her writings had ever appeared on my reading lists, and I only vaguely remembered reading a chapter about her in an old book called *Critics and Crusaders*.

Not long after receiving my doctorate, I attended a conference in Pennsylvania. Sometimes at conferences you run into interesting people, and this time I ran into Richard Drinnon, a remarkable historian. Drinnon told me he had written a biography of Emma Goldman: *Rebel in Paradise*. So I went to find it and read it, and it just astonished me. It made me angry about the fact that I had not been told anything about Emma Goldman in my long education. Here was this magnificent woman—this anarchist, this feminist, this fierce, life-loving person. Of course, that led me to her autobiography, *Living My Life*, which, if you have not read,

you should read. At a certain point, I decided to require it for a class of 400 students. At first I thought, *Living My Life* is a *big* book. And I asked myself, will they really connect with this early twentieth-century woman, while here we are in the 1960s?

My students loved it. And they found in her what I found: a free spirit, boldness, a woman who spoke out against all authority, unafraid, and, as the title of her book suggests, living her life as she wanted to live it, not as the rules and regulations and authorities were telling her how to live it. That got me interested in Emma Goldman: in reading her and using her stuff in my classes.

It wasn't until around 1975, however, the year the war in Vietnam ended, that I had a breathing spell and could actually address Emma Goldman at length. I had always been interested in theater: My wife had acted, my daughter had acted, my son was in the theater and still is—and I had always been interested in the theater and never done anything with it, because I was always too

involved in the civil rights movement, and in the Vietnam War movement. So I wrote a play about Emma Goldman and I had to make a decision. Her life was so long and full, and in any work of art—I like to call what I do art—there's always a problem of what to leave in and what to leave out. There's so much to her life, so I started with her as an immigrant girl, a teenager living in Rochester, New York, and working in a factory.

Her political awareness takes a leap in 1886 at the time of the Haymarket affair, which occurs all over the country in the midst of labor struggles for the eight-hour day. There's a strike against the International Harvester Company in Chicago. The police come. It's the usual scene, police versus strikers. But the police fire into the crowd of strikers and kill a number of them. At that time, Chicago was a great center for radical activity and anarchist groups. The anarchists call a protest meeting in Haymarket Square. It's a peaceful meeting, but the police barge into the meeting and a bomb explodes in the midst of the police—a terrorist attack. Nobody knows who

threw the bomb. But, you know, when a terrorist attack occurs, it doesn't matter whether you know or don't know. You've got to go after somebody. The police have to find somebody. The FBI has to find somebody. The army has to find somebody. So they find eight leading anarchists in Chicago. Nobody can tie them to the throwing of the bomb, but they're anarchists. We have conspiracy laws. Conspiracy laws are very interesting. With a conspiracy law, you can tie anybody to anything. You don't have to do anything to become the defender in a political conspiracy trial. So they quickly find these eight anarchists guilty of conspiring to murder, and they are sentenced to death.

Emma Goldman is aware of this. It goes up through the courts. The American judicial system is a wonderful system. Once errors have been made at a lower level, they are very often hard to overcome because the higher courts will limit themselves in what they can review. They'll say, "Well, the jury and the judge considered the facts in this case, so all we have to deal

with are the legal niceties, and we can't go over the facts." In any case, the Illinois Supreme Judicial Court approved the sentences.

The Haymarket affair became an international issue. It was one of those cases that capture the imagination of caring people who see injustices. In our time, we've had so many such cases: the Rosenbergs and Mumia Abu-Jamal, for example, became international causes. That was true of the Haymarket affair. George Bernard Shaw sent a telegram to the Illinois Supreme Court saying, "If the state of Illinois needs to lose eight of its citizens, it could better afford to lose the 8 members of the Illinois Supreme Court." It didn't help. Four of them were hanged, and when the news came out and Emma Goldman heard about it, it excited her to the point of fury. She soon left Rochester, left her family, left a husband from what was really an arranged marriage when she was very young. She went to New York and joined a little anarchist group. In New York she met Alexander Berkman, who became a comrade and then her lover. This little group of

anarchists living in a collective in New York began putting out literature, handing it out, doing what these little left-wing groups do. Anybody who walks through Park Square or Harvard Square will encounter these people. It's important to pick up their information, to pick up those leaflets, because they will tell you things—these crazy, radical people—that you will never hear anywhere else.

Anyway, Emma Goldman is part of this little group. In 1892, a strike takes place in Homestead, Pennsylvania, against the Carnegie Steel Works. The Pinkerton Detective Agency, which is a euphemism for strikebreakers, is hired by the Carnegie Corporation. They are hired by Henry Clay Frick, whom you may know as an art patron, but who was also a manager of the steel works and the employer of the Pinkerton strikebreakers. There's a gun battle and strikers are killed. As a result, this little anarchist group in New York gets fired up. They decide that they are going to do what has not been done in the United States but has been done

a number of times in Europe: They will show that the perpetrators of violence can also be the victims of violence. They decide to kill Henry Clay Frick.

They argue about it. You can imagine this little group; they are not very experienced at this sort of stuff. They discuss it all night. How will we do this? Where will we get a gun? Berkman volunteers to do it, but they'll have to get him a new suit of clothes. If you're going to kill someone, you have to look respectable. And so he goes with his new clothes and his gun to Pittsburgh, and barges into Frick's office, and he's a very poor shot. He's an anarchist. What do you expect? He hadn't practiced this stuff. He knows how to hand out leaflets. So he only wounds Frick.

Berkman is arrested, quickly tried, and sentenced to twenty-two years in prison. He's been Emma Goldman's lover, and while he's in prison she becomes a nationally known figure, writer, lecturer, fierce woman. By the way, one of the great books about prison conditions and the

whole issue of prisons is Berkman's *Prison Memoirs of an Anarchist*. It's a wonderful book. Berkman spent fourteen years in prison, and by the time he came out things had changed. He and Goldman were no longer lovers. But they soon founded an anarchist magazine together, *Mother Earth*, and were publishing things that nobody else would publish.

They had by this time changed their minds about the necessity for occasional acts of political violence. They had pretty much decided, after rethinking, that violence is the kind of thing you have to avoid. They were organizers, and Goldman was an organizer of garment workers in New York while she was speaking all over the country.

Sometime around 1908, Emma Goldman took up with a fascinating character named Ben Reitman. Reitman was a doctor, sort of. Then again, he was everything, sort of. Somehow he made his way through medical school by reading things on his own, listening to lectures, even taking over for the lecturer, a famous physician,

one day when the physician wasn't there. Ben Reitman just went up to the podium and delivered a lecture on the same subject.

He was a swashbuckling character, always wearing a cowboy hat. He ran a street clinic for women who needed help, gynecological advice, abortions. He was a risk taker, a devilish person— and a very handsome devil who absolutely captivated Emma Goldman, this independent woman who wasn't not supposed to be captivated by anybody. This is one of the interesting things about her life: She was a strong woman, she insisted on the independence of women—but when she fell in with Ben Reitman, she became absolutely swallowed up in this very, very passionate ten-year-long affair.

Reitman was an anarchist among anarchists. But he had courage, too. He and Goldman went out to San Diego where there was a ferocious attack on them by all sorts of people who saw anarchists as the devil. Reitman was kidnapped and taken out into the countryside, where he was tarred, feathered, and branded on his back-

side with the letters "IWW"—Industrial Workers of the World. He was the kind of guy who later, when he appeared on a platform, would suddenly turn his back to the audience and pull down his pants to show them what had been done to him, which horrified Goldman. A lot of things about Reitman horrified her, but it didn't stop their relationship. What stopped it was politics, and World War I.

By then Emma Goldman had spent considerable time in prison. She had been imprisoned on Blackwell's Island in New York for speaking out during the economic crisis in 1893. There was a fierce economic situation in New York, and all over the country, in that year. Huge numbers of people were unemployed. They did not have enough food to take care of their families. Emma Goldman got up in front of a huge crowd in Union Square and said, "If you don't have food enough for your kids, go into the stores and take the food." It's called direct action. That's what anarchists believe in. You don't sign petitions. You don't lobby. You don't visit your legislator.

You take direct action against the source of your problem. That's what workers do when they go on strike; it's what women do when they take direct action against men, or against the source of their oppression. Goldman was jailed for making that suggestion. Her jail record was a very long one. The FBI always had people following her, and the police reported on her speeches. They couldn't record one of her speeches because, as the agent reported to his superiors, "Well, she spoke to this group of Jewish women on the Lower East Side, and I'm sorry I couldn't take down what she said because she spoke in Yiddish."

By the time World War I came on, both Emma Goldman and Alexander Berkman had spent quite a bit of time in prison. By now she was a famous speaker and lecturer, and she began to speak out against the war and the draft. World War I was the occasion for a kind of hysteria that happens again and again in wartime. People who speak out against the war are looked on as a kind of traitor; the government induces an atmos-

phere of fear and makes examples of a small number of people in order to intimidate everybody else. In this case, in World War I, they imprisoned about one thousand people for speaking out against the war. When Emma Goldman and Alexander Berkman spoke at a big rally against the conscription act, they were arrested, sent to prison, and not released until the war ended.

In a situation not far off from the current post–9-11 treatment of immigrants and noncitizens in the United States, when the war ended the government launched into a wholesale roundup of people who were noncitizens. There was no due process, no trial, no hearing—you just put them on a boat and deported them. Emma Goldman and Alexander Berkman were deported, ironically enough, back to Russia where they had been born—though at that time it was czarist Russia, and by the time of their deportation, in 1919, it had become Soviet Russia.

But they were both still anarchists. Even though they had first welcomed the overthrow of

the czarist regime, they soon found themselves at odds with the new Bolshevik regime precisely because they were anarchists. They were antiauthoritarian and antistate. At the time, Maxim Gorky was putting out a little dissident newspaper, but it didn't last long because the Bolsheviks were rounding up dissidents. As opponents of the regime, Goldman and Berkman soon left the Soviet Union and settled in Western Europe. They picked a warm spot, the Mediterranean coast of France, and lived in very modest way there, separately, but still friends and still involved in things happening here. Alexander Berkman became sick and died in 1936. Emma Goldman died in 1940 in Canada when she was making a rare visit to North America.

Wherever I go now, I have to talk about the current war—that's what's happening, what people are thinking about. People are talking about terrorism, people are talking about war, and I have

to talk about it or I'm not doing my duty to myself: to move from the past into the present. Emma Goldman was an absolutely incorrigible fighter against war who spoke out against the Spanish-American War, against World War I. Anarchists in general, being antiauthoritarian and not trusting governments (I can't imagine why they don't trust governments), are instinctively antiwar.

I always want to know what people are thinking. I spoke this morning to Cambridge Rindge & Latin High School, an assembly of about 300 students. There, too, I spoke about the war. It's clear that people all over the country have been bombarded with the notion that we must support the war, support the president; we must have unity, we mustn't dissent; you're either for us or against us. If you raise questions about U.S. foreign policy, the retort is "Oh, you're justifying the attacks on the Twin Towers." Or if you say that there are alternatives to war, people are equally wary. Plenty of people already have been visited by the FBI for criticizing the war and the

president. The incidents have multiplied around the country. A retired worker out in the West who made a remark critical of President Bush at his sports club was visited by the FBI and asked, "Are you a member of the sports club? Did you make this remark about the president?" A young woman was visited by the FBI, who said, "We hear you have a poster on your wall with a picture of Bush in a very unflattering way," meaning: We must flatter Bush.

This is scary. This is totalitarian. Congress passed the USA PATRIOT Act in which terrorism is defined in such a way to enable government officials to pick up a person just for something they say. We're living at a time when it becomes even more important to dissent from the establishment and the president, when everybody's crying, "We must unite behind the president." It's exactly at such a time when we need dissenting voices. The irony is that it's exactly in times of war—when you're dealing with life-and-death matters—that you're not supposed to speak. So you have freedom of

speech for trivial matters, but not for life-and-death matters. That's a nice working definition of democracy, isn't it? But it shouldn't be that way. This is exactly when we need the most lively discussion, so wherever I go these days I try to contribute to that discussion.

I spoke recently at Newton North High School, just outside Boston. I spoke to about 500 students about the war, and afterwards about four or five parents reacted angrily. They showed up at a school committee in Newton, saying, "Why did you invite him? Why would you let him speak?" Then the Newton newspapers (not a lot happens in Newton) were full of letters and columns for weeks all about. . . me. I have to say this as modestly as I can. I say this only to indicate that apparently to raise questions about the war is to engender a kind of ferocity that goes against democracy. So yes, I speak out and write regularly against the war—I write a column for *The Progressive*.

On both pragmatic and moral grounds, I'm opposed to the wars in Afghanistan and Iraq.

Pragmatically, I wonder if these wars are very effective in reducing terrorism. Despite the billions of dollars extra going to military and homeland security budgets, people are still worried about terrorism. Have you noticed that people's fears about terrorism have diminished because of the war? Since the war? I don't see that. If anything, anxiety is growing. We set out to say, "Well, here are these terrorists. We're going to find Osama bin Laden." We didn't—and even if we did, would that be dealing with terrorism? Well, we found this group, that group; we bombed the caves in Afghanistan. They said there were *thousands* of fighters in the caves. They came up with a handful of people. Where are the others? As we learn from the government itself, there are terrorist networks in many parts of the world—maybe forty or fifty countries— but it changes from day to day, just like the numbers of Communists in Joseph McCarthy's State Department used to change. The truth is that no one knows how many there are.

If you don't know where the terrorists are, I

ask, what are you doing bombing Afghanistan and Iraq? There may be a network in the Philippines, in Syria, in Somalia—who knows where? Clearly, by bombing and bombing we haven't done anything about terrorism. It's as if a crime had been committed, a mass murder, and you're looking for the perpetrators, and you hear that they are hiding out in Cambridge. Bomb Cambridge! Or to get rid of the criminals in this neighborhood—you bomb the neighborhood! You can do so just on the chance that this might result in killing the criminal. This is what we've been doing in Afghanistan—and it's absurd, from a pragmatic point of view.

Then on the moral point of view. How many innocent civilians have we killed with our bombing? That's what an article I recently wrote for *The Nation* is about. I was reading the *New York Times*, which had a page every day with photos of the victims from the World Trade Center and the Pentagon—little photos and biographical sketches—that was very moving. The page would describe who these people were,

what they did, what they cared about, what their hobbies were, and who their families were. Suddenly the numbers—3,000 or whatever it is—becomes not numbers but human beings. And I thought, well, we haven't done the same thing to our victims in Afghanistan and Iraq. They are still just numbers, just as the victims in the Twin Towers were just numbers to whoever planned those attacks in New York and Washington. And I like to think, not specifically of the perpetrators of the attacks, but about a significant number of people around the world who were *just* sad about the attacks, well that's too bad, but they weren't repelled by it. I wonder if those people who didn't feel repelled by the attacks were deluded by the fact that they only knew about numbers—the people in the Twin Towers were just numbers to them. If they had encountered them, seen their faces, talked to their families, a lot of these people would begin for the first time to recognize what had been done here in New York. Conversely, if the American people could know, really know up close—and see the pictures, meet

the families, and visit the hospitals of the victims of our bombing in Afghanistan—then would they continue to support the bombing? I suspect that the reason the American people support the bombing is because they believe Donald Rumsfeld, because we have no one else talking to us. You turn on the TV, and there he is. You turn off the TV, and there he is. You can't escape him. He is very calm and blithe. If there are questions about civilian casualties he says, "Oh, well, we try our best. We don't really mean to kill any civilians. These things happen. Collateral damage, right?"

Remember Timothy McVeigh, when he was asked about the Oklahoma City bombing? Timothy McVeigh said of the children who died: "Collateral damage." He'd learned this during the first Gulf War, when this phrase was used by the United States to describe Iraqi civilians dying under U.S. bombs. And so this is Rumsfeld: collateral damage, an accident, unintentional. Or: "They're deliberately putting civilians in military targets." That always gets to me. A village is

destroyed. You mean they populated this village with ordinary people so that then it would become a propaganda weapon against the United States—they created a Hollywood set? No, there's something wrong with that. History is important here. When you're dealing with an event like this, what's happening in Afghanistan or Iraq, if you don't have any history about American wars or American foreign policy, it's as if you were born yesterday. Then whatever people tell you, you have no way of checking up on it.

It's important to remember the lies that were told to the people of this country during past wars. Lies about, "Oh, we're only bombing military targets"—and a million civilians died in Vietnam. I was in North Vietnam in 1968 and 1972. I saw villages a hundred miles away from a military target (as if there are that many military targets in Vietnam) totally destroyed by attacking jet planes. With some of that history, you know that the government lies all the time. These things are not accidents. When I say that, I don't mean that the government goes out to

deliberately kill someone. I mean that they don't care, because it's inevitable. When something is neither deliberate nor an accident, and there's something in between, the something in between is inevitable. And so when you do the bombing on this scale, it's inevitable that you'll kill large numbers of civilians. As for the numbers of civilians killed in Afghanistan, nobody knows. The Pentagon doesn't know, or won't tell, and some of their responses are: "Well, we're not there on the ground; we don't know." You can't believe the Taliban; you can't believe the Pentagon. But if you put together the dispatches in American newspapers, those scattered on the back pages of the *New York Times*, the *Washington Post*, and the *Chicago Tribune*; and you read Reuters and Agence France-Presse; and you read in the *Guardian* and the *Times* of London; and you put all those scattered pieces together, you come up with a horrifying picture of the human damage that we have done in Afghanistan and Iraq. That is a moral disaster. We've met terrorism with terrorism. So I'm argu-

ing, from both a pragmatic and a moral point of view, that war is indefensible. People ought to speak out and defy the admonitions to keep patriotic, which use a very distorted definition of patriotism, and instead create a discussion about what is going on. Or else we become victims, as people all over the world have become victims to their governments, and have allowed wars to go on endlessly, one after the other.

Those of us who speak and act against war are part of a noble historical tradition—of Henry David Thoreau committing civil disobedience to protest the Mexican War, Eugene Debs and Emma Goldman and Helen Keller criticizing U.S. entrance into World War I, the G.I.s who came back from Vietnam and insisted that the war come to an end, the young men and women in the military who have risked court martial to speak against the wars in Afghanistan and Iraq.

Stories Hollywood Never Tells

~

An edited version of a talk given at the Taos Film Festival, Taos, New Mexico, April 17, 1999.

When I began reading history and studying history and teaching history and writing history, I kept coming across incidents and events and people that led me to think, "Wow, what a movie this would make." However hateful they may have been sometimes, I have always loved the movies. When I would read about things in history, I would then look to see if a movie had been made about it. But it was never there. It took me a while to realize that Hollywood isn't going to make movies like the ones I'd been thinking about. Hollywood isn't going to make movies that have the effect of making people more class

conscious, or more antiwar, or more conscious of the need for racial equality or sexual equality. No, they're not going to make movies like this.

I wondered about this. It seemed to me that it wasn't really an accident. You could say it was just an oversight on the part of Hollywood that they have not made a film about the Ludlow massacre in Colorado—just an accident, like the accidents you hear about if you turn on the television, as I turned it on this morning. They were explaining the "accident" that happened when NATO forces bombed a column of refugees from Kosovo. These things are always accidents. Now you might say, "They're not really deliberate. They did not really mean to do this." But they are rarely accidents.

That is, the people in Hollywood didn't all get together in a room and decide, "We're going to do just this kind of film and not the other kind of film." Nobody in NATO headquarters or the U.S. government had to get together and say, "We are going to bomb civilians." They don't have to do that, and yet it's *not* an accident. Somebody at

one point used an expression to describe events that are not accidents, not planned deliberately, but something in between. He called it "the natural selection of accidents," in which, if there's a certain structure to a situation, then these things will inevitably happen, whether anyone plans them or not. The structure of war is such that innocent people are going to killed. I heard President Clinton say, "Well we didn't mean this, but civilian casualties are inevitable when you carry on war." He was absolutely right, which then leads you to two conclusions: either you just have to accept civilian casualties, or you have to do away with war. Of course, you know, the second is unthinkable.

It seems that the structure of war is such, and the structure of Hollywood is such, that it will not produce the kinds of films that I imagined when I read and began to write history. There is a structure that you can describe simply as "based on the need to make lots of money"; a structure where money and profit are absolutely the first consideration before art, before aesthet-

ics, before human values. When I was invited to this film festival I thought, "Well, here's my chance. Here are filmmakers. I'll tell them about things I've wanted to see done on film, so they can all immediately go out and do it."

I think about making films that will make war abhorrent to people. When you consider the films about war that have come out of Hollywood—and there have been hundreds and hundreds and hundreds, maybe even thousands, of films about war—they are almost always films that glorify military heroism. There are occasional departures from that, but mostly it's military heroes, military heroism, and the kind of films that will not persuade young audiences that they should not immediately go to war and embrace war. I began to think about telling the story of wars from a different perspective; when you look at war from a different perspective, you come up with all sorts of scenarios.

I'll take one of the best of our wars to begin with: the Revolutionary War. How can you speak against the Revolutionary War, right? To tell the

story of the revolution, not from the standpoint of the Founding Fathers, but from the standpoint of war as a complex phenomenon intertwined with moral issues, we must see that Americans were oppressed by the English—and we must also see that some Americans were also oppressed by other Americans. The Revolutionary War was not simple. For instance, American Indians did not rush in exultation to celebrate the victory of the colonists over England, because for them it meant that the line that the British had set against westward expansion in the Proclamation of 1763 would now be obliterated. The colonists would be free to move west into Indian territory. American Indians did not celebrate the American Revolution. Black slaves did not celebrate the American Revolution.

It was estimated that maybe one-third of the colonists supported the American Revolution, one-third were opposed, and one-third were neutral. This was the estimate of John Adams, one of the Founding Fathers and one of the revolution-

ary leaders. I thought it would be interesting to tell the story of the American Revolution from the standpoint of an ordinary working man who hears the Declaration of Independence read to him from a balcony in Boston, promising freedom and equality and so on, and immediately is told that rich people can get out of service by paying several hundred dollars. This man then joins the army, despite his misgivings, despite his own feelings of being oppressed—not just by the British, but by the leaders of the colonial world in which he is having such a hard time surviving— because he is promised some land. But as the war progresses and he sees mutilations and killings, he becomes increasingly disaffected. There's no place in society where class divisions are more clear cut than in the military, and he sees that the officers of the Revolutionary army are living in high splendor while the ordinary enlisted men don't have any clothes or shoes, aren't being paid, and are being fed slop. So he joins the mutineers.

In the Revolutionary War, there were mutinies against Washington's army: the

mutiny of the Pennsylvania Line, the mutiny of the New Jersey Line. I thought it would be interesting to tell the story of a working man who joins the Revolutionary army and fights in battles and is wounded, but who then joins the Pennsylvania Line, and they mutiny. They march on the Continental Congress but finally they are surrounded by Washington's army, and several of their comrades are forced to shoot several of the mutineers. Then this soldier, embittered by what he's seen, gets out of the army and gets some land in western Massachusetts. After the war is over, he becomes part of the rebellion. There is a rebellion in western Massachusetts called Shays's Rebellion, in which small farmers rebel against the rich men who control the legislature in Boston who are imposing heavy taxes on them, taking away the land and farms of the families who live there. Shays's Rebellion is a popular rebellion of Revolutionary War veterans, as well as of other small farmers who surround the courthouses and refuse to let the auctioneer go in to auction off their farms. The

militia is then called out to suppress them, and the militia also goes over to their side, until eventually an army is raised by the moneyed people in Boston that finally suppresses Shays's Rebellion.

I have never seen Hollywood tell this kind of story. I talked to someone who really knows a lot about film and I told him, "You know, I think that probably at some point I am going to say I'm waiting for a film like this to be made, and then somebody will say 'Yes, it was made.'" But I don't think that film I just described was made. And if I describe a film that I think should be made, and you know that it has already been made—I wish you'd let me know so we can have a celebration of that rare event.

Wars can be described in such a way that complicate the simple "good versus evil" scenario presented to us in our history books and in our culture. Wars are not simply wars of one people against another; wars always involve class differences within each side, where victory is very often not shared by everybody, but only by a few.

The people who fight the wars are not the people that benefit from the wars.

I thought somebody should also make a movie about the Mexican War. I haven't seen anything on it that tells how the Mexican War started, or how the president of the United States deceived the American people. I know it's surprising to hear that a president would willfully deceive the people of the United States, but this was that one rare case in which President James Polk told Americans that Mexican troops had fired at us on U.S. soil. It wasn't, in fact, U.S. soil—it was disputed soil that both the Mexicans and the Americans had claimed. During this incident, people were killed—and zoom, we were at war, a war that had been planned in advance, before this incident, by the Polk administration because they coveted this beautiful territory of the Southwest.

It would be interesting to tell that story again from the standpoint of an ordinary soldier in the Mexican War, who sees the mayhem and the bloodshed as the army moves into Mexico and destroys town after town. Such a story would

describe how more and more of these soldiers grow disaffected from the war, and as they're moving on the final march under General Scott toward Mexico City, General Scott wakes up one morning and discovers that half of his army has deserted. It would be interesting to tell it from the point of view of one of the Massachusetts volunteers who comes back at the end of the war and is invited to a victory celebration over how half of Mexico had been taken away by the United States. As the commander of the Massachusetts volunteers is being honored up at the podium, he gets up to speak and he is booed off the platform by the remaining half of the Massachusetts volunteers who are still alive—who think about what happened to their comrades in the war, and who look around and wonder what they were fighting for. I should tell you: that really happened.

The story would also include a scene in which the American army is moving to take control of territory seized from Mexico. The invading troops march on northern Mexico, into what is now called New Mexico. They move into Santa

Fe, where they must suppress a rebellion because mostly Mexicans live there, and the United States government is taking it over. The army marches through the streets of Santa Fe after their military victory. All the people of Santa Fe go into their houses and close the shutters, and the army is met by total silent resistance, which is an expression of how the population feels about this great victory of the American army.

Another little thing about the Mexican War, which might make the movie a little more interesting, is the story of some of the deserters. A lot of the people who volunteered in the Mexican War did so for the same reason that so many of the poor and working-class people volunteer for the military today. It's not that they are imbued with the idea of going to war; they're just desperately poor and they hope that their fortunes will improve as a result of enlisting. During the Mexican War, some of these volunteers were recent immigrants, many of them Irish. A number of these Irish immigrant soldiers, as they watched what was being done to the people of

Mexico, deserted and went over to the Mexican side. I don't know how many of you know about it; maybe in New Mexico people know more about this, in fact I'm sure people in New Mexico know more about this than people in other parts of the country. They formed their own battalion, fighting with the Mexicans, which they called St. Patrick's battalion (which became the San Patricio battalion), and this becomes an amazing event in the Mexican War.

I was reminded of that as I thought of the war in Philippines, right after the Spanish-American War. It's not easy to make the Spanish-American War a noble enterprise—though of course Hollywood can do anything—but I don't think it's gotten a lot of attention in film. In the text-books and the history classes, the Spanish-American war is called "a splendid little war." It lasts three months. A short victory over the Spaniards. We did it to free the Cubans, because we're always going to war to free somebody. We expel the Spaniards from Cuba, but we don't expel ourselves from Cuba, and the United

States in effect takes over Cuba from that point on. One of the things that we have against Fidel Castro is that he broke into that long uninterrupted control of Cuba by the United States. Though the Cuban revolution is a complicated thing, I think it's fair to say that it's one grievance that the United States has against Castro. I can't believe the grievance they have against him is simply because he's a dictator, because we've never held grudges against dictators, you see.

The Spanish-American War gets a certain amount of attention, because there's the heroism of Theodore Roosevelt, the Rough Riders, and all of that. I remember learning about it in school, but they never said anything about the war in the Philippines. We learned something about how, as a result of the Spanish-American War, we took over the Philippines, but I never knew the details.

When you look into it, the Spanish-American War lasted three months; the Philippine War lasted for years and years and was a brutal, bloody suppression of the Filipino movement for

independence. In many ways, it was a precursor of the Vietnam War, if you look at the atrocities committed by the American army in the Philippine Islands. Now that's a story that has never been told, though it would not accrue to military heroism or to the glory of the United States to tell that story. There were black American soldiers in the Philippines, who soon began to identify more with the Filipinos than with their fellow white Americans. They were very conscious of the fact that while these black soldiers were fighting to suppress the Filipinos, they also were hearing from back home about the lynchings and race riots that were taking place in their hometowns. They were hearing about black people being killed in large numbers—and here they were, fighting against colored people, against non-white people, for the United States government. A number of black soldiers deserted and went over to fight with the Filipinos.

In 1906, when the Philippine War was supposed to be over—but really the American army

was still suppressing pockets of rebellion—there was a massacre. That's the only way to describe it. The "Moros" are inhabitants of a southern island in the Philippines, and there was a Moro village composed of 600 men, women and children—all of whom were unarmed. The American army swooped down on them and annihilated every last one of them. Mark Twain wrote angrily about this. He was especially angry about the fact that President Theodore Roosevelt sent a letter of congratulations to the military commander who did this, saying it was a great military victory. This happens again and again: When the military does heinous things, they are congratulated for great military victories. Have you ever seen a movie in which Theodore Roosevelt was presented as a racist? As an imperialist? As a supporter of massacres? And there he is up on Mount Rushmore. It would take a lot to change that. I've had the idea— a hammer, a chisel—no, it wouldn't do.

War needs to be presented on film in such a way as to create a new population of people who

will simply say "no" to war. We need to see that more and more. We need a film about those heroic Americans who protested against World War I. There were socialists, there were pacifists, there were people who just saw the stupidity of the war that was taking the lives of 10 million people in Europe and that now the United States was entering. We look for people who can be really interesting as characters in films. Look at some of the people who, at that important point during World War I, opposed the war. You see Emma Goldman, the feminist and anarchist, who goes to prison for opposing the draft and the war. You see Helen Keller; I haven't seen Helen Keller in any film other than the kind of film that concentrates on the fact that she was a disabled person. I've never seen a film in which Helen Keller is presented as what she was: a radical, a socialist, an antiwar agitator. She was somebody who would refuse to cross a picket line set up against a play that was about her. What a remarkable subject for a film. I think also of Kate Richards O'Hare, the socialist who

was put in jail for opposing World War I. There could be a great scene when she's in the prison, where they are stifling for lack of air. She takes a book that she's been reading, reaches through the bars, and hurls the book through a skylight above a prison corridor to let the air in. All the prisoners applaud and cheer because finally they're getting some fresh air.

I could say a lot more about possible stories and scenarios about war. What about World War II? Again, a good war. The best of wars. But it's not that simple, and that's why Studs Terkel, when he did his oral history called *A "Good War,"* put quotation marks around "good war," if you noticed. In that war, we have humanitarian sympathies, we are fighting against a terrible evil (fascism); but on the other hand, we have a war marked by our own atrocities that multiplied as the war went on, culminating in Hiroshima and Nagasaki. I have not seen a film that has dealt with our bombing of Hiroshima. The closest we've come to a film that deals with our bombing of civilian populations was the film made of

Kurt Vonnegut's book, *Slaughterhouse-Five*, and that was an oddity, a rarity.

I have to acknowledge that there were a few antiwar films made about World War I. *All Quiet on the Western Front* is an example of an absolutely extraordinary film. I recently compared *Saving Private Ryan* to *All Quiet on the Western Front* in an article I wrote. I thought that, despite the mayhem, *Saving Private Ryan* was essentially a glorification of war; whereas we had that absolutely diamond clear anti-war expression in *All Quiet on the Western Front*.

There are so many issues connected with class, class conflict, and class struggle in America that we could deal with in movies. We've had movies that deal with working-class people, but it's always some individual person in the working class who rises up out of his or her situation individually and "makes it" in American society. Stories of Americans who organize and get together along class lines to oppose the powers that hold them down—now that has been very rare. You do not see films

about the struggles of the textile girls: the girls who went to work in the textile mills of Massachusetts, in Lowell and Lawrence, from the early nineteenth century. There's a marvelous story there about the Lowell girls of the 1830s who organized and went on strike. You'll not see films about what they did. You'll not see films about all of the rich history of labor struggles that took place in the United States. After all, the American system set up by the Constitution, the American political system, and the revered and celebrated Constitution of the United States did not grant any economic rights to the American people. We very often forget that the Constitution gives political rights but not economic rights. Even those political rights are circumscribed by the nonexistence of economic rights. If you are not wealthy, then your political rights are limited, even though they exist on paper in the Constitution. The freedom of speech is something that exists there, but how much free speech you have depends on how much money you have and what access to

resources you have. But as far as economic rights, there are none in the Constitution. Here's the Declaration of Independence: the right to life, liberty, and the pursuit of happiness. But how can you have life, liberty, and the pursuit of happiness if you don't have the right to food, housing, and health care?

Working people all throughout history have had to organize, struggle, go on strike, declare boycotts, and face the police and the army and the National Guard. They had to do it themselves, against the opposition of government, in order to win the eight-hour day, in order to somewhat change their working conditions. So I say a great film remains to be made about the railroad strikes of 1877, or about the Haymarket affair of 1886, which was part of the struggle for the eight-hour day. The Haymarket affair culminated in the execution of four anarchists who were charged with planting a bomb, though in the end nobody ever found out who really planted it.

What about the story of Eugene Debs and the great railroad strike of 1894, in which they tied

up the railway system of the United States and all the power of the army and the courts had to be brought against them? Debs is another character for a movie, but I've never seen a movie in which he was the central figure. I've seen all sorts of pitiful central figures in movies, but never the magnificent Eugene Debs, who starts off as an organizer of railroad workers, and they send him to jail, and he comes out of jail a socialist. Jail will do that to people, so they'd better be careful about how many people they send to prison—we now have 2 million people in prison, and if all of them did as Debs did, well! When he was finally released after being sent to prison for opposing World War I—not by the liberal Woodrow Wilson but by the conservative Warren Harding—Debs had made such an impression on his fellow prisoners that, as he was being let out of prison, the warden opened up all the jail cells and let everybody out into the yard. They all applauded and shouted as Debs was given his freedom.

A movie needs to be made—and I met someone who is actually writing a script—about the

Lawrence textile strike of 1912, a magnificent episode. It was magnificent because a lot of strikes are lost; this strike was won. It was a multicultural strike of people who spoke twelve different languages, got together, and defied the textile companies and the police, who were sent to the railroad to prevent the children of the workers from leaving. Police attacked the women and children at the railroad station because they didn't want the children to be sent away and looked after; what the police wanted was to starve out the strikers, which would be less likely to happen if their children were safe. But the strikers held out, and they were helped by the IWW, the Industrial Workers of the World, and they finally won. Out of that strike comes the song "Bread and Roses." It's a wonderful episode.

There's also the Ludlow Massacre, which took place during the Colorado coal strike of 1913–14. It was one of the most bitter, bloody, dramatic strikes in American history, against the Rockefeller interests. It's not easy to make a film against the Rockefeller interests. One of its lead-

ers was Mother Jones, an eighty-three-year-old woman who had organized in West Virginia and Pennsylvania. Mother Jones led children on a march from Pennsylvania to Oyster Bay, New York to confront President Theodore Roosevelt, because these kids were working in the textile mills at the age of eleven and twelve. She got permission from their parents and marched with these kids all the way to New York, where Theodore Roosevelt was having summer vacation. They stood there with their signs, which say "We Want Time to Play." Has there ever been a film made about Mother Jones? She's eighty-three years old, arrested by the National Guard in Colorado, thrown into dungeons, and still leads the women of the strike in marches through the city of Trinidad, Colorado.

Of course, good movies and wonderful documentaries have been made. I'm talking about what Hollywood hasn't made. But we've never had so many wonderful documentaries as we've had in the last ten or fifteen years. These are documentaries that have to struggle to raise the

money and then struggle, struggle to be distributed and to be seen by people. There are amazing successes. I think that Michael Moore's film *Roger and Me*, which has been seen by tens of millions of people, is remarkable. So the possibilities do exist to play a kind of guerrilla warfare with the system and make films and show films outside of the Hollywood establishment. Sometimes you might sneak something in there—and so you always try and see if you can make them forget for a moment who they are and what they stand for.

We've had films on Christopher Columbus, but I don't know of any film that shows Columbus as what he was, as a man ruled by the capitalist ethic. Is Hollywood going to make a film that puts down the capitalist ethic of killing people for gold, which is what Columbus and the Spaniards were doing? A great film could be made, and one of the figures in it could be Bartolome de la Casas, who exposed what Columbus did in volumes. Las Casas was an eyewitness to what was going on, and there could be a scene of the remarkable

debate that took place before the royal commission of Spain in 1650. This great debate was between Las Casas and Sepulveda, another priest who argued that the Indians were not human and therefore you could do to them anything that you wanted to do to them.

There's also the story of the removal of the Cherokees from the Southeast—of the Trail of Tears and Andrew Jackson, one of our national heroes. I didn't learn in school that Jackson was a racist and an Indian killer; that he signed the order to expel the American Indians from the southeast part of the United States across the Mississippi. That was ethnic cleansing on a very large scale: the march of the American armies across the continent, driving the Indians from their homeland to a little space in Oklahoma that was then called Indian Territory. When oil was later discovered there, Indian Territory was once again invaded. It was then no longer to be called Indian Territory. Now this was really ethnic cleansing. No movie depicts the story of the Cherokee Trail of Tears, of the 16,000 people

marching westward and the 4,000 who died on this march, while the American army pushed them and the American presidents extolled what had happened.

Of course there is also the story of black people in the United States finally told from the black people's point of view. We've had a number of films about the Civil Rights movement from which you see the story of the Montgomery bus boycott from Sissy Spacek's point of view. You see the story of the murder of the three civil rights workers in Mississippi in 1964 from the standpoint of the FBI, who are the heroes of this film; but every person who was in Mississippi in 1964—my wife and I were both there at the time—knew that the FBI was the enemy. The FBI was watching people being beaten and not doing anything about it. The FBI was silent and not present when people needed protection against murder. In this Hollywood film, they become heroes. We need the story of the Civil Rights movement told from the standpoint of black people, and the story of

Mississippi told from the standpoint of Fanny Lou Hamer.

I want to say just one little thing about the Civil War. The Civil War is again one of our "good wars"—the slaves were freed in the course of it—but it is not that simple. There is the class element of who was drafted and who was not drafted; who made huge amounts of money off the Civil War, and the paying of substitutes; and what happened to Indians. When you see documentaries on the Civil War, what you see mostly are battle scenes. You see Gettysburg and Fredericksburg and Bull Run. When I run into someone, they often say, "Oh, you're a historian. I am very interested in the Civil War." And they proceed to tell you about the Battle of Fredericksburg, since that's what we see as the Civil War: the battles. Or black people being freed. But there's another angle to it—just an element to it that at least complicates the picture. In the midst of the Civil War, while the Union armies are fighting in the South, there's another part of the Union army that is out West, destroy-

ing Indian settlements and taking over Indian land. In 1864, not long after the Emancipation Proclamation, the American army is out in Colorado attacking an Indian village, killing hundreds of men, women, and children at Sand Creek, Colorado, in one of the worst Indian massacres in American history. This massacre occurred during the war for freedom. In the years of the Civil War, more land was taken away from the Indians than in any other comparable period in history. There's a lot of historical work to be done, a lot of films that need to be made.

If such films are made and reach the public, about war, class conflict, and who controls what; and about the history of governmental lies, broken treaties, and official violence; if those stories are told, we might really produce a new generation. As a teacher and a writer, that's what I'm interested in. I'm not interested in just producing books, and I'm not interested in just reproducing class after class of people who will get out, become successful, and take their obedient places in the slots that society has prepared for

them. What most of us must be involved in—whether we teach or write, make films, write films, direct films, play music, act, whatever we do—has to not only make people feel good and inspired and at one with other people around them, but also has to educate a new generation to do this very modest thing: change the world.

Pamphleteering in America

~

This is an edited and revised version of an essay that was originally published as the introduction to Open Fire: The Open Magazine Pamphlet Series Anthology, *Greg Ruggiero and Stuart Sahulka, editors (New Press, 1993, New York).*

Perhaps the most important publication in the history of the United States was neither a book nor a periodical, but a pamphlet. It was Thomas Paine's *Common Sense*, which appeared in the English colonies of North America early in 1776 and emblazoned across the sky the bold, exciting idea that was in the mind of more and more colonists: Independence from England!

Paine's words were simple, his logic powerful, his message provocative: "Society in every state is a blessing, but government even in its best state is but a necessary evil." And the

English monarchy, he went on to say, was far from the "best state." So why endure its rule? "I challenge the warmest advocate of reconciliation to show a single advantage that this continent can reap by being connected with Great Britain," Paine wrote.

England had involved the colonists in war after war. There was no practical economic advantage to remain an English colony. Paine laid on argument after argument, like a master bricklayer, and then came to an emotional climax: "Everything that is right or reasonable pleads for separation. The blood of the slain, the weeping voice of nature cries, 'TIS TIME TO PART."

Common Sense went through twenty-five editions and sold hundreds of thousands of copies. It was the best of best sellers. Considering that the population of the country then was about 3 million, if just 100,000 were sold, that would be the equivalent of 8 million copies of a pamphlet sold today in the United States.

The thought leads to flights of fancy. What if someone today were to write a pamphlet—elo-

quent, persuasive, powerful—explaining why the American people should declare their independence of the government and set up their own decision-making bodies, more democratic, more responsive to their needs? And what if the country were in such a state of depression, going through such a crisis of confidence in our political leaders, that 8 million U.S. citizens bought such a pamphlet? Might that not be a unifying force for a Second American Revolution or some radical change approximating a revolution?

Pamphlets are almost as old as printing itself, and they became popular because they met an urgent need. Printing a book is always costly and time-consuming. Newspapers are cheaper and quicker but fleeting in impact. A pamphlet, bound but with paper covers, combined the advantages of both: It was low-priced, produced in no time, but something that could be kept, pored over, and passed on to others. Furthermore, pamphlets have been especially useful to express the ideas of dissidents, being short (from five pages to a hundred or so), writ-

ten in language that ordinary people could understand, and easy to conceal from the authorities when that was necessary.

In the mid-1600s in England, the anarchist ideas of "The Diggers," arguing against private property and the tyrannical government, were disseminated in pamphlets. The Diggers got their name from their insistence that they could take over unused land—even if it "belonged" to someone legally—if it were needed by someone without a place to live or a plot of land to till. A pamphlet by Gerard Winstanley, one of the Diggers, argued their case to the English public, at a time when England was going through the turmoil of the Puritan Revolution against monarchical power.

Tom Paine's *Common Sense* was the most widely read pamphlet of the Revolutionary period, but it was not alone. More than four hundred pamphlets appeared in the twenty-five years preceding the Declaration of Independence, arguing one side or another of the conflict before the English crown and the colonists, discussing questions of disobedience to law, loyalty to

authority, the rights and obligations of citizens in a society.

Early in the rule of the new government of the United States, Congress passed and President John Adams signed the Sedition Act, which made it a crime to say anything "false, scandalous, or malicious" against the government, Congress, or the president, with intent to "bring them into disrepute." Ironically, it came seven years after the First Amendment was added to the Constitution, as if to state the lesson early on: In the real world, constitutional promises are one thing and political realities are another.

The act, despite its intimidating language (and the subsequent jailing of a number of dissenters) led to newspaper columns and pamphlets denouncing it. George Hay, a member of the Virginia House of Delegates, produced a pamphlet, *An Essay on the Liberty of the Press*, arguing: "A man may say anything which his passions suggest. . . ."

Hay's pamphlet influenced a pamphlet that appeared in 1800, shortly after his, which was

The Report on the Virginia House of Delegates, written by James Madison and therefore carrying the prestige of the "Father of the Constitution." In the *Report*, Madison argued brilliantly against the reasoning, used by the justices of the Supreme Court, that allowed the Sedition Act to stand.

In this same period, the grievances of the French people, which led to their great Revolution of 1789, were expressed throughout France in pamphlets, or *cahiers* (literally, "note-books"; actually, petitions or statements in pamphlet form). One pamphlet, *Patriotic Reflections*, by a law professor in Rennes, put the resistance to change the Old Regime in a universal context: "Negro slaves—you are reduced to the condition of brutes—but no innovations! Children of Asiatic kings—the custom is that the eldest of you strangle his brothers—but no innovations!"

The two privileged estates in France before the Revolution were the nobility and the clergy. The Third Estate—everyone else—was subordinate. The pamphlets of the Revolution therefore expressed a new class-consciousness. The Abbe

Sieyes wrote, in a famous pamphlet *What is the Third Estate?*, that the Third Estate was the nation; the nobility and the clergy he compared to "a malignant disease that preys upon and tortures the body of a sick man."

The French Revolution, however, in its *Declarations of the Rights of Man*, and in its restrictions of the right to vote to male taxpayers, did not fulfill its promise of universal democracy. And so, in 1791, the French actress Olympe de Gouges wrote the pamphlet *Declaration of the Rights of Women and Citizenesses*, which protested the exclusion of women from the promises of the Revolution.

In England at this time, Mary Wollstonecraft was writing her powerful argument for the equality of women, *A Vindication of the Rights of Women*, in which she said that men were themselves degraded by the subordination of women. And in the United States, the first half of the nineteenth century saw a burst of female protest, as pamphleteering became a principle way of communicating with the nation. The sisters

Sarah and Angelina Grimké, from a family of slaveowners in South Carolina, became abolitionists and feminists and were the first women to speak publicly to mixed audiences. Sarah Grimké's pamphlet, *Letters on the Condition of Woman and the Equality of the Sexes*, was published in Boston in 1838 and gained wide attention. A small sample of it reads:

> Man has inflicted an unspeakable injury on woman, by holding her up to view her animal nature, and placing in the background her moral and intellectual being. Woman has inflicted an injury on herself by submitting to be thus regarded. . . .

Later on in the century, when the right to vote for women became an issue, there appeared a pamphlet, *"Common Sense" Applied to Woman Suffrage*, which became a classic in the literature of the suffrage movement. It was by Dr. Mary Putnam-Jacobi, who was the first woman physician elected to the New York Academy of Medicine. She pointed to the

changed nature of "women's work," which was so frequently nondomestic, and thus to the baselessness of a man's control over his wife's property and earnings.

In the movement for the abolition of slavery in the United States, pamphleteering was an essential weapon. One of the earliest and most powerful was *Walker's Appeal*, written in 1829 by David Walker, son of a slave, who now lived as a free man in Boston where he sold old clothes. Walker was an early militant, and his language has a Malcolm X ring to it:

> Let our enemies go on with their butcheries, and at once fill up their cup. Never make an attempt to gain our freedom or natural right from under our cruel oppressors and murderers, until you see your way clear—when that hour arrives and you move, be not afraid or dismayed. . . . God has been pleased to give us two eyes, two hands, two feet, and some sense in our heads as well as they. They have no more right to hold us in slavery than we have to hold them. . . . Our sufferings will come to

an end, in spite of all the Americans this
side of eternity. . . . 'Every dog must have its
day,' the American's is coming to an end.

The pamphlet infuriated Southern slavehold-
ers. The state of Georgia offered rewards to kill
him or deliver him alive. The following year,
David Walker was found dead near the doorway
of his shop in Boston.

It was common to transcribe lectures and
speeches and distribute them in pamphlet form.
Henry David Thoreau, who had expressed his
opposition to the Mexican war and to slavery by
refusing to pay his taxes and going to jail, later
gave a lecture entitled "Resistance to Civil
Government." This lecture was then printed as a
pamphlet, *Civil Disobedience*: "It is not desir-
able to cultivate a respect for the law, so much as
for the right."

In the late nineteenth century, farmers in the
United States organized the Populist movement,
to defend themselves against the powerful corpora-
tions that were squeezing them into poverty

("Wall Street owns the country," one of their leaders told a Populist convention in Kansas). The movement set out to create an independent culture for farmers, to reeducate millions of farm families in politics, economics, law, and philosophy. It set up a lecture bureau, with 35,000 lecturers who traveled through the country and distributed thousands of pamphlets to carry on this reeducation.

The anti-imperialist movement that rose up in the nation during the time of the Spanish-American War and the conquest of the Philippines also produced considerable pamphlet literature. These pamphlets were intended to inform the American people of the atrocities committed against people overseas, all for the sake of creating an American empire.

Although the labor movement of this period, dominated by the American Federation of Labor, was conservative in many ways, it expressed itself strongly against American overseas expansion. One pamphlet, written by Bolton Hall, treasurer of the American Longshoreman's Union, was called *A Peace Appeal to Labor* and declared: "If

there is a war, you will furnish the corpses and the taxes, and others will get the glory."

The great radical union of the early twentieth century, the Industrial Workers of the World (IWW), which represented the poorest, the least skilled, and the most exploited of American workers, found the newspaper and pamphlet to be natural forms of expression. After the IWW was formed in 1905, the *Preamble to its Constitution*, a defiant call for class struggle, was printed in hundreds of thousands of copies and distributed all over the country and abroad. It began: The working class and the employing class have nothing in common. There can be no peace so long as hunger and want are found among millions of working people and the few, who make up the employing class, have all the good things of life. Between these two classes a struggle must go on until the workers of the world organize as a class, take possession of the earth and the machinery of production, and abolish the wage system. . . .

In the decade before World War I, countless pamphlets were produced during the labor strug-

gles and battles for free speech of the IWW. That war gave the government an excuse to prosecute, and effectively destroy, the IWW. But there were exultant moments of solidarity even in defeat, and exultation in occasional victories. One of the high points in the history of the IWW was its leadership in the 1912 strike of 25,000 textile workers in Lawrence, Massachusetts. Many of the strikers were recent European immigrants, a majority of them women and children. A woman physician in Lawrence reported that a third of the men and women working in the mill died before they reached the age of twenty-five.

Two extraordinary Italians became important to the strike: Joseph Ettor, an IWW leader who could speak English, Italian, and Polish, and Arturo Giovanetti, a poet and orator, who took charge of the relief operation for the strikers. When a striker was shot and killed, the two were arrested and jailed for "inciting" murder, though neither was at the scene. At their trial, they made closing statements that were also printed as a pamphlet. Ettor told the jury:

> Does the District Attorney believe . . . that
> the gallows or guillotine ever settled an
> idea? If an idea can live, it lives because his-
> tory adjudges it right. I ask only for justice.
> . . . An idea consisting of a social crime in
> one age becomes the very religion of
> humanity in the next. . . .

After a long trial, during which they were kept in cages in the courtroom, they were acquitted.

Radicalism and pamphleteering have always been natural partners. Surely the most influential piece of political literature in modern history was the hundred-page *Communist Manifesto* of Karl Marx and Frederick Engels. And all over the world, socialist, communist, and anarchist movements have depended on the power of such writing: concise analyses, passionate arguments, and inspiring visions of a new society.

Of the many pamphlets produced in the course of the Russian Revolution, those of V. I. Lenin (*What Is to Be Done?*, *Left-Wing Communism: An Infantile Disorder*, *State and Revolution*, and many more) are the best known. But we should

also take note of the writings of Alexandra Kollontai, Bolshevik and feminist. As one who criticized the Soviet bureaucracy from within for distancing itself from the people (in her pamphlet *The Workers' Opposition*), she was writing in the same vein as Rosa Luxemburg, who protested the limitations on democracy in the new Soviet State. In her 1914 pamphlet, *Working Woman and Mother*, Kollontai wrote in plain language about the problems of women in Tsarist Russia. One of her statements struck a special chord in the United States in 1992, when conservative opponents of a woman's right to choose spoke on defending "family values." Kollontai wrote: "The humbugs and hypocrites of the bourgeoisie maintain that the expectant mother is sacred to them. But is that really in fact the case?"

As for anarchism, no one expressed its ideas with greater simplicity and clarity than Alexander Berkman, whose *The ABC of Anarchism* was printed as a cheap pamphlet by a group of English libertarians. And we can find no more colorful and daring presentation of the fem-

inist viewpoint (which landed her in jail several times) than Emma Goldman, whose speeches (like the infamous one deriding marriage as "an insurance contract" and declaring that marriage had "nothing in common" with love) were reprinted as pamphlets in the early years of the twentieth century.

The pamphlets of history are a perfect expression of the marriage of art and politics— their language is the language of the people, their cheapness makes them accessible to all, their content is revolutionary, demanding fundamental changes in society. Like all socially conscious art, they transcend the world of commerce, they transcend the orthodox, and so they are profoundly democratic. So long as war and injustice remain, artists will find ways to make their art follow Shakespeare's plea in *King John*:

> O that my tongue were in the thunder's mouth!
> Then with a passion would I shake the world.

Notes

~

1 Mark Twain, "Comments on the Killing of 600 Moros," in *Mark Twain on the Damned Human Race*, ed. Janet Smith (New York: Hill and Wang, 1994), 110–20; Helen Scott, "The Mark Twain They Didn't Teach Us About in School," *International Socialist Review* 10 (Winter 2000): 61–65.

2 Mark Twain, *A Connecticut Yankee in King Arthur's Court* (New York: Bantam Classic, 1994), 64–65.

3 Emma Goldman, "Patriotism, a Menace to Liberty," in *Anarchism and Other Essays*, ed. Richard Drinnon (New York: Dover Publications, 1969).

4 The lines from "i sing of Olaf glad and big". Copyright 1931. Copyright 1959, 1991 by the Trustees for the E. E. Cummings Trust. Copyright © 1979 by George James Firmage, from *Complete Poems: 1904–1962* by E. E. Cummings, edited by George J. Firmage. Used by permission of Liveright Publishing Corporation.

5 Dalton Trumbo, *Johnny Got His Gun* (New York: Bantam Books, 1982).

6 Eugene O'Neill to Eugene O'Neill Jr., June 1, 1942, in Eugene O'Neill, *Selected Letters of Eugene O'Neill*, ed. Travis Bogard and Jackson R. Bryer (New Haven: Yale University Press, 1988), 528–29.

7 From *The Collected Poems of Langston Hughes* by Langston Hughes, © 1994 by The Estate of Langston Hughes. Used by permission of Alfred A. Knopf, a division of Random House, Inc.

8 Joseph Heller, *Catch-22* (New York: Scribner, 1996).

9 Tom Brokaw, *The Greatest Generation* (New York: Dell Books, 2001).

10 Pablo Picasso, *Picasso on Art: A Selection of Views*, ed. Dore Ashton (New York: Da Capo Press, 1972), 21.

11 Heller, *Catch-22*, 252–55.

12 Ibid., 257.

13 Ibid., 335.

14 Kurt Vonnegut, *Slaughterhouse-Five* (New York: Dell, 1991).

15 Lon Tuck, "It's Been a Long Time But . . . Eartha's Back!" *Washington Post*, January 19, 1978, p. B1.

16 "Masters of War" © 1963 by Warner Bros. Inc. Copyright renewed 1991 by Special Rider Music. All rights reserved. International copyright secured. Reprinted by permission.

17 Howard Zinn and Noam Chomsky, ed., *The Pentagon Papers, Senator Gravel Edition, Vol. 5: Critical Essays* (Boston: Beacon Press, 1972), 4.

18 Zachary Coile, "Smart Bombs Put U.S. Strikes Under Greater Scrutiny," *San Francisco Chronicle*, January 13, 2002, p. A6.

19 Daniel Berrigan, "In Loving Memory–Mitchell Snyder." Poem in author's collection. See revised draft, "To the New York West Side Jesuit Community," in Daniel Berrigan, *And the Risen Bread: Selected Poems, 1957–1997*, ed. John Dear (New York: Fordham University Press, 1998), v. Reprinted by permission.